ACROSS ASIA
AND THE
ISLAMIC WORLD

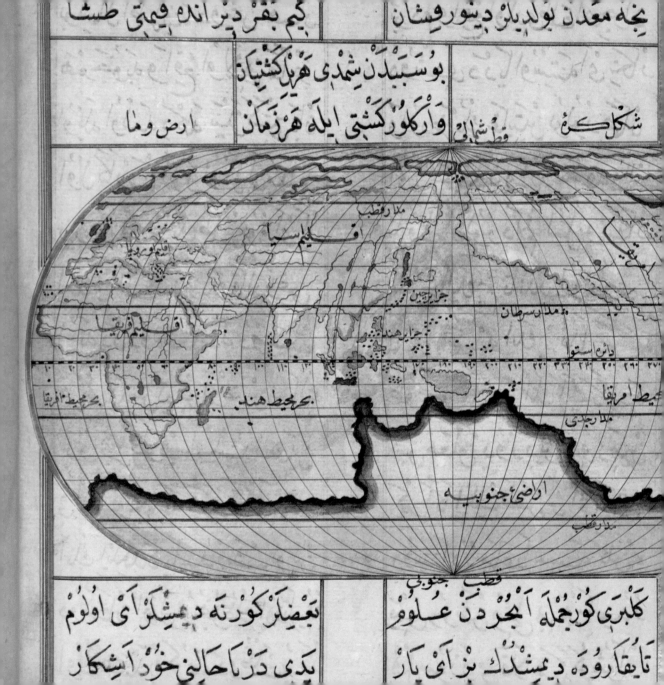

بنجه معدن بولديلو دينور فشان | كيم بقر دنر انده قيمتي طشا

بو سبيدن نشمدى هريك كشتيان | شكل كره

واركلور كشتى ايله هر زمان | قطب شمالى

ارض وما

ملتقا قطب

اقليم آسيا

جزاير جين

ملد سرطان

جزاير هند

دائره استوا

بحر محيط هند

محيط امريقا

بحر محيط افريقا

مدار جدى

اراضى جنوبيه

مدار قطب

قطب جنوبى

كلبرى كوريحمله آبجردن علوم | بعضلر كورنه دميشلر آى اولوم

تايقارود دميشلد بز آى يار | يدى در ك حالنى خود آشكار

ACROSS ASIA AND THE ISLAMIC WORLD

**Movement and Mobility in the Arts
of East Asian, South and Southeast Asian,
and Islamic Cultures**

Series editor: Ruth Bowler, Volume editor: Adriana Proser,
with a foreword by Julia Marciari-Alexander, Andrea B.
and John H. Laporte Director, The Walters Art Museum

Essays by Adriana Proser, Dany Chan, and Ashley Dimmig

| THE WALTERS | **g**
| ART MUSEUM |

The Walters Art Museum, Baltimore, in association with D Giles Limited

The Walters Art Museum
600 N Charles St.
Baltimore, MD 21201
https://thewalters.org/

Julia Marciari-Alexander, Andrea B. and John H. Laporte Director
Ruth Bowler, Director of Publication and Digital Production

© 2023 The Trustees of the Walters Art Gallery, Baltimore

First published in 2023 by GILES
An imprint of D Giles Limited
66 High Street,
Lewes, BN7 1XG, UK
gilesltd.com

ISBN: 978-1-913875-22-0 (softcover edition)

Where multiple dimensions are given, height precedes width
precedes depth.

For D Giles Limited:
Copy-edited and proofread by Jodi Simpson
Designed by Alfonso Iacurci
Produced by D Giles Limited
Printed and bound in China

For the Walters Art Museum:
Copy-edited and proofread by Melanie Lukas
Photography by Ariel Tabritha, Elena Damon, and Susan Tobin
(p. 57 imaged by Gregory Bailey)
Map by Tony Venne

Across Asia: Arts of Asia and the Islamic World is made possible thanks to
support from the Institute of Museum and Library Services, E. Rhodes
and Leona B. Carpenter Foundation, The Freeman Foundation, Judy
and Scott Phares / The Witt/Hoey Foundation, PNC, The Herbert
A. Silverman Fund for Asian Art, The Gary Vikan Exhibition Endowment
Fund, The Hilde Voss Eliasberg Fund for Exhibitions, The Walters
Women's Committee Legacy Endowment, and an anonymous donor.

This publication was made possible through the support of The Andrew
W. Mellon Fund for Scholarly Research and Publications, the Sara
Finnegan Lycett Publishing Endowment, and the Francis D. Murnaghan,
Jr., Fund for Scholarly Publications.

Library of Congress Cataloging-in-Publication Data

Names: Walters Art Museum (Baltimore, Md.), author. | Alexander, Julia
 Marciari, 1967- writer of foreword. | Proser, Adriana G. | Chan, Dany. |
 Dimmig, Ashley.
Title: Across Asia and the Islamic world : movement and mobility in the
 arts of East Asian, South and Southeast Asian, and Islamic cultures /
 contributions by Adriana Proser, Dany Chan, and Ashley Dimmig.
Description: Baltimore : The Walters Art Museum ; Lewes : in association
 with D Giles Limited, 2023. | "Series editor: Ruth Bowler, Volume
 editor: Adriana Proser, with a foreword by Julia Marciari-Alexander,
 Andrea B. and John H. Laporte Director, The Walters Art Museum." |
 Includes bibliographical references. | Summary: "The Walters Art Museum
 is among America's most distinctive museums, forging connections between
 people and art from cultures around the world that span seven millennia.
 The museum holds a stunning array of objects, from richly illuminated
 Qur'ans and images of the Buddha to captivating narrative paintings and
 artfully crafted ceramics and metalworks. Highlighting the strengths,
 variety, and sheer wonder of the Walters Art Museum's unique Asian and
 Islamic collections, Across Asia and the Islamic World is the first
 volume in a series of titles that break away from the traditional
 academic approach. It is built around themes that transcend period,
 form, locale, and medium, and showcases the museum's initiative to
 develop new ways of interpreting its collections"-- Provided by
 publisher.
Identifiers: LCCN 2022037222 | ISBN 9781913875220 (paperback)
Subjects: LCSH: Art objects, Asian. | Islamic art objects. | Art and
 society--Asia. | Art and society--Islamic countries. | Art
 objects--Maryland--Baltimore. | Walters Art Museum (Baltimore, Md.)
Classification: LCC NK1037 .W35 2023 | DDC 709.5--dc23/eng/20220824
LC record available at https://lccn.loc.gov/2022037222

Front cover illustration: Detail of Fig. 4
Back cover illustration: Detail of Fig. 17
Frontispiece: Detail of Fig. 25
Page 10: Detail of Fig. 2
Page 26: Detail of Fig. 11
Page 46: Detail of Fig. 20
Page 62: Detail of Fig. 14

Unless otherwise indicated, location names for the map
on pp. 8–9 follow those used by the United Nations at the
time of publication.

Contents

Foreword

Works of art created by artists from Asia and the Islamic world have held places of pride at the Walters Art Museum since the earliest days of its opening to the public, first as a private collection from 1877 and then as a public museum after 1934. By the time they were acquired by William Walters and his son Henry for their collections, many of these objects had already traveled across the world and were in the hands of dealers based in New York and Paris, some with connections in China, Japan, Istanbul, and Cairo. Some were purchased at the opulent displays at World's Fairs and international expositions that attracted both William and Henry during their lifetimes. Not limited to those works collected by its founders, the museum's collections of art from Asia and the Islamic world have continued to expand to this day and number in the thousands thanks to generations of generous donors and curatorial acumen.

Movement is an intrinsic part of the life of most art objects. Those that have been conveyed from great distances of space and time to the Walters Art Museum in Baltimore are sources of fascinating stories and deep insights. Edited

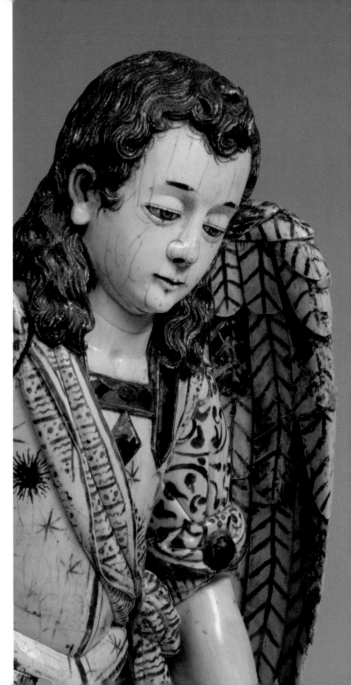

by Adriana Proser, this small but rich volume coincides with the opening of the Walters' new galleries, Across Asia: Arts of Asia and the Islamic World. Its authors, Dany Chan, Ashley Dimmig, and Adriana Proser, focus on two dozen works from the museum's holdings and demonstrate in their essays how movement, both of art and reflected in works of art, has enriched cultures across the globe. They also explore some of the ways in which art and movement have stimulated spiritual ascendancy for thousands of years and, more somberly, how some objects are also testaments to the regions' complex histories of colonization and conquest. This volume brings together a variety of works in many media created or sourced in places ranging from China, India, Japan, the Philippines, and Thailand to Iran, Türkiye (Turkey), and West Africa to tell stories that are as unique as they are compelling.

Thanks are due not only to the authors whose creativity and expertise have made this volume possible but also to Ruth Bowler, who enthusiastically championed the project since its inception, and to Melanie Lukas for her keen editorial eye. Collaboration among the curators, conservators, and conservation scientists has led to insights that would not have been possible otherwise. These collaborators include Gregory Bailey, Pamela Betts, Angela Elliot, Karen French, Glenn Gates, and Abigail H. Quandt. We all remain indebted to the work of our staff photographers, led by Ariel Tabritha, and to the research insights of all our predecessors, from curators and conservators to the many past interns and fellows who have studied these wonderful collections. Special thanks goes to Hiram W. Woodward, Jr., the museum's Curator Emeritus of Asian Art, who generously shares his insights and research with museum staff to this day.

JULIA MARCIARI-ALEXANDER
ANDREA B. AND JOHN H. LAPORTE DIRECTOR

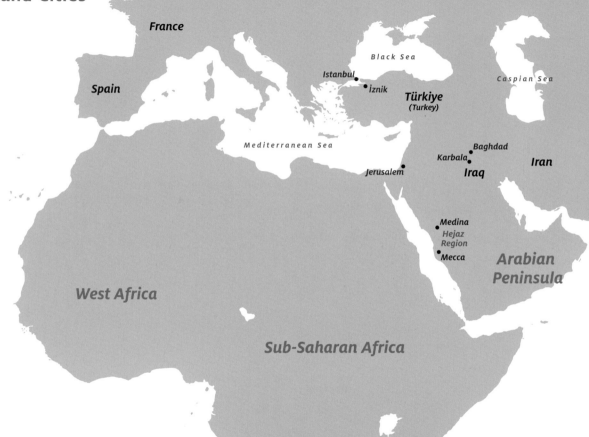

Map of Asia & The Islamic World with Selected Countries, Regions, and Cities

France

Spain

Black Sea

Istanbul
İznik

Türkiye
(Turkey)

Caspian Sea

Mediterranean Sea

Jerusalem

Karbala
Baghdad
Iraq

Iran

Medina
Hejaz
Region

Mecca

Arabian
Peninsula

West Africa

Sub-Saharan Africa

*at the time of publication the historical region of Bengal is divided between Bangladesh and the Indian state of West Bengal

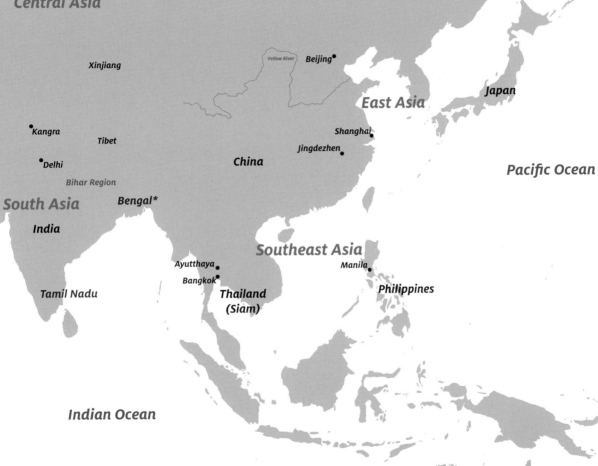

Central Asia

Xinjiang

Yellow River

Beijing

East Asia

Japan

Kangra

Tibet

Shanghai

Jingdezhen

China

Pacific Ocean

Delhi

Bihar Region

South Asia

Bengal*

India

Southeast Asia

Ayutthaya

Manila

Bangkok

Tamil Nadu

Thailand
(Siam)

Philippines

Indian Ocean

EXPANSION AND EXCHANGE ACROSS BORDERS

DANY CHAN
ASSOCIATE CURATOR OF ASIAN ART

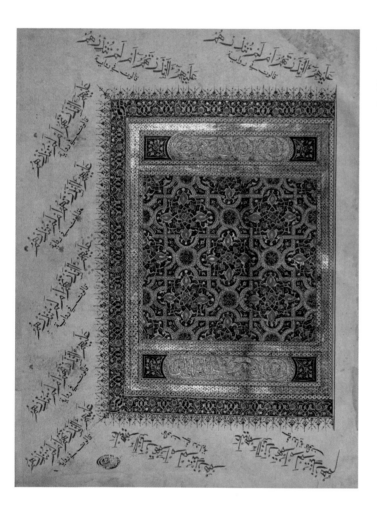

Fig. 1a

Owner's Seal from a Qur'an, Northern India, 15th century, ink, opaque watercolor, and gold paint on thin laid paper, with brown leather binding with gold, 15¾ × 12³⁄₁₆ in. Acquired by Henry Walters, before 1931, acc. no. W.563, fol. 8a

For thousands of years, art objects have traversed the vast landmass that is now defined as the continent of Asia. Many objects exhibit qualities that cross geographic and cultural borders. The complexity of influences and inspirations that result from acts of expansion and conquest or exchange and appropriation, which is an act of unacknowledged adoption of elements of a culture or identity by others, has yielded rich and surprising results.

One marvelously illuminated Qur'an (Figs. 1a, 1b) opens with a series of intricate frontispieces, with different types of script composing the main text and explanatory notes in the margins. The manuscript demonstrates the extensive reach of Islam, from northern India to the Ottoman capital city of Istanbul. The style and color of the illumination suggest that it was produced in the workshops of one of the Muslim princely courts in fifteenth-century northern India. By 1512, however, the manuscript had traveled from India to Istanbul and arrived at the court of Ottoman Sultan Bayezid II (r. 1481–1512), probably as a diplomatic gift to maintain good relations between the two courts. At the time,

Fig. 1b

Incipit from a Qur'an, Northern India, 15th century, ink, opaque watercolor, and gold paint on thin laid paper, with brown leather binding with gold, 15¾ × 12³⁄₁₆ in. Acquired by Henry Walters, before 1931, acc. no. W.563, fol. 8b

Indian Muslims participated in a network of commercial, diplomatic, and artistic exchanges that extended throughout Asia, Europe, and Africa. The seal of the sultan appears on one of the folios (Fig. 1a).

Just as works made of paper, ink, and paint can attest to Asia's long, complex history of expansion, so can objects made from other materials like hardstones, ceramics, and ivory. During China's Qing dynasty (1644–1911), jade made its way into Chinese court rituals taking place far from where it was sourced. In this period, great efforts were made to recreate the rituals of the past as a way, among others, to legitimize the dynasty's rule. This gilded jade chime (Fig. 2), dated to 1764, was made for the Chinese court for such a purpose. In Chinese culture, jade has been a desired material for millennia and is believed to embody spiritual transcendence. A jade chime has additional associations with ritual music and rulership. It was believed that playing the proper court music would manifest harmony in society. Yet, the jade used in making this chime is also emblematic of conquest: it was quarried from

Fig. 2
Chime from an Imperial Set, China,
dated 1764, jade (nephrite) and gold,
11 7/16 × 19 × 1 1/8 in. Acquired by Henry
Walters, before 1931, acc. no. 42.274

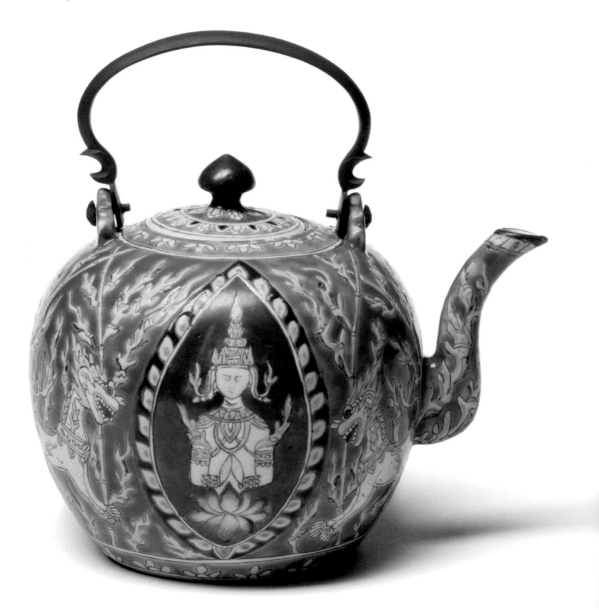

the territory of Xinjiang, the region west of the Chinese empire that was conquered just five years prior. Although many of the exchanges between Xinjiang and China since the seventh century had been transmitted primarily along trade routes, the Qing emperors successfully asserted control over the region and formally incorporated it into the Chinese empire, creating a new Xinjiang province. Local peoples were engaged not only to mine the material but also to oversee the mining enterprise. Jade, in this case, connected ritual and rulership with expansion and conquest. The creation of this jade chime represented the Chinese emperor's ability to legitimize his subjugation of a new territory and its people and to inscribe his power there with an intentional symbol of conquest.

Fig. 3

Teapot, China, 19th century, porcelain with enamels, 5¼ × 6¹¹⁄₁₆ × 5⅛ in. Gift of the Doris Duke Charitable Foundation's Southeast Asian Art Collection, 2002, acc. no. 49.2799

Qing dynasty rulers, like many others who held power in China before them, fostered commercial engagement with foreign nations. This teapot with Siamese imagery (Fig. 3) exemplifies the reach of China's long-standing ceramics trade with Southeast Asia. For centuries, tea drinking has been popular among all levels of society in Siam, known today as the Kingdom of Thailand. The Siamese used teapots in a variety of sizes, shapes, and materials. This example is fashioned out of porcelain and decorated with colorful enamels, a type of ceramic known as *bencharong* (five-colored). Bencharong ceramics demonstrate artistic and commercial exchanges between Siam and China since the fourteenth century. Their characteristic style of multicolored enamels applied on a white porcelain base is derived from Chinese ceramics made during the Ming dynasty (1368–1644). In fact, many bencharong ceramics, including this teapot, were manufactured in China for the Siamese market; specifically, bencharong ceramics were found in Jingdezhen, the famed site in southeastern China, where porcelain is produced for both domestic use and export

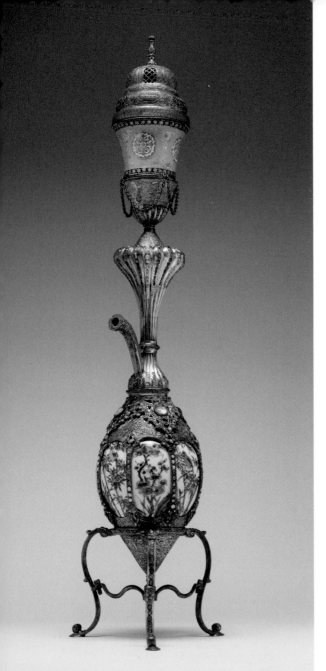

around the world. Meanwhile, the Siamese city of Ayutthaya served as a trading post within the maritime trade routes that connected East Asia and Southeast Asia and beyond. Siamese buyers sent porcelain orders with desired designs and decorative motifs to kilns in China, perhaps with officials to make sure that the order was filled to the desired standard. For example, on this teapot are two traditional Siamese figures of half-length celestial beings in *thepphanom*, a worshipful position, each flanked by *singha*, mythical lion-like beasts that protect the Buddha and the Buddhist path.

Among the many works of ceramics traveling across Asia, the highly renowned blue-and-white porcelains from China were especially prized in Islamic courts. Such objects were not only collected by Muslim rulers but also refitted

Fig. 4

Nargile, China and Türkiye, ca. 1720 (vessel), mid-19th century (water pipe), gilded silver and copper alloy, porcelain, enamels, rubies (spinels), and emeralds (beryls), 26 3/16 × 6 7/8 × 6 5/16 in., diam.: 3 3/8 in. Acquired by Henry Walters, 1903, acc. no. 49.2199

or refashioned for new purposes. This nargile, or water pipe (Fig. 4), incorporates an eighteenth-century Chinese blue-and-white vessel that was later embellished in the mid-nineteenth century with Ottoman fittings, including gilded silver, copper, rubies, and emeralds. Refitted in this way, the Chinese ceramic vessel would have held water for the smoking process, most likely disregarding the original function of the vessel as a vase or something similar. In 1903, Henry Walters traveled to Istanbul where he bought, from the dealer Robert S. Pardo, over twenty items decorated with gilding and jewels. This nargile is listed by Pardo as coming from the collection of the Turkish ambassador to the court of the Shah.

The impact of the Qing dynasty's eighteenth-century porcelain trade resulted in wealthy European households frequently collecting Chinese imports or objects with decorative schemes created in what was understood to be a Chinese style, or chinoiserie. This elaborate scent container (Fig. 5) is an example of the craze for chinoiserie. Here a porcelain figure of the Chinese deity Budai and a wine cup are framed in an elaborate gilded bronze arbor covered with French-made porcelain flowers. Budai, a tenth-century Chinese monk, is named after the cloth sack (*budai*) that he often carries under his arm. Believed to be the incarnation of Maitreya, the future Buddha, Budai helps common people in the mortal world. In art, he was popularly depicted as a jovial figure with a laughing face and round stomach, an appearance that speaks to his lighthearted perspective and approachable nature. In its original context, such a sculpture of Budai would have been placed on an altar to be worshipped. In this piece made for use in an eighteenth-century French interior, however, the Chinese deity becomes part of an ensemble to be used as a container for potpourri. The figure of Budai is possibly made more comical, a figure to be laughed at, by the

Fig. 5

Scent Container with Figure of Budai, China and France, 1745–49, porcelain, soft paste porcelain, and ormolu, 13 9/16 × 13 7/8 × 8 in. Museum purchase, 1941, acc. no. 54.2261

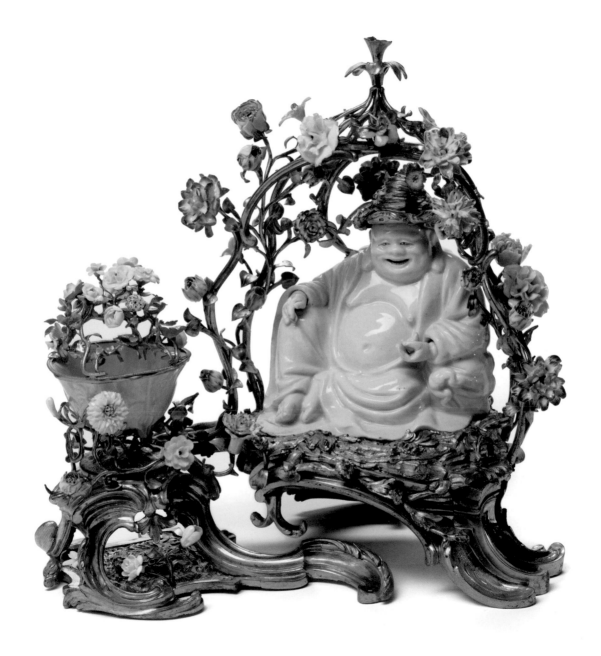

addition of a gilded bronze cap. This reframed and repurposed ceramic ensemble suggests its European audiences had either no knowledge of, or perhaps no regard for, the ceramic's original function or meaning.

Similarly, an ivory sculpture of the Archangel Michael (Fig. 6) tells an even more complex tale of exchange, as well as expansion across a global geography. The sculpture was made in the Philippines by immigrant Chinese artisans. The ivory used to create it was at least partially sourced from African elephants. The figure of Michael is from the European Catholic faith, in which he serves as the defender of the Church; this role is represented by both the sword and scales (not pictured) in the figure's hands. As a result, the sculpture possesses a complex mix of Asian artistic styles, African materials, and European art traditions. The finished sculpture was then exported to the Americas and then possibly to Europe. These points of connection were part of Spain's colonial enterprise during the seventeenth century. Spain devised a trade network, called the Manila Galleon Trade, to connect the Philippines (Asia) and Mexico (the Americas). It was a network that actively moved materials, images, and ideas around the globe—as well as a wide variety of people, among them missionaries, artisans, and enslaved individuals.

These artworks illustrate the myriad and complex ways that objects can move across borders through acts of expansion and conquest or exchanges and appropriations. But they do not tell the whole story. Ongoing research demonstrates that these complexities are often still being understood, and the histories surrounding the objects are continuing to evolve.

Fig. 6

The Archangel Michael, Philippines, ca. 1670–90, elephant ivory with gilding and paint, marble base, h.: 46 9/16 in. Acquired by Henry Walters, before 1931, acc. no. 71.490

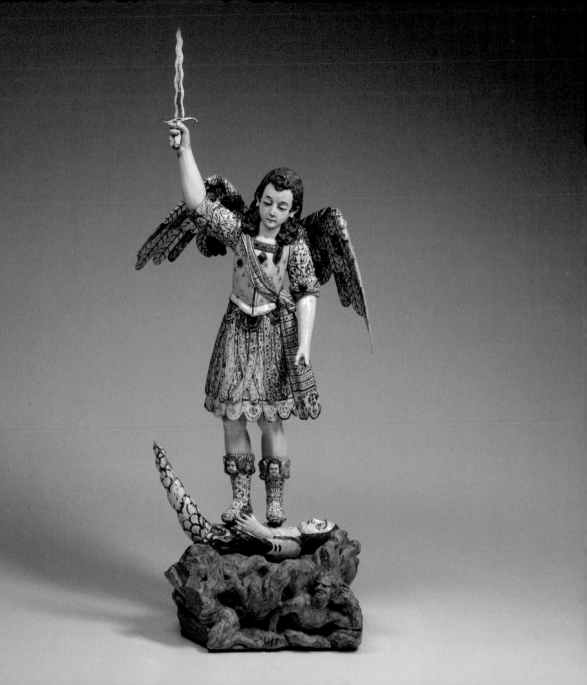

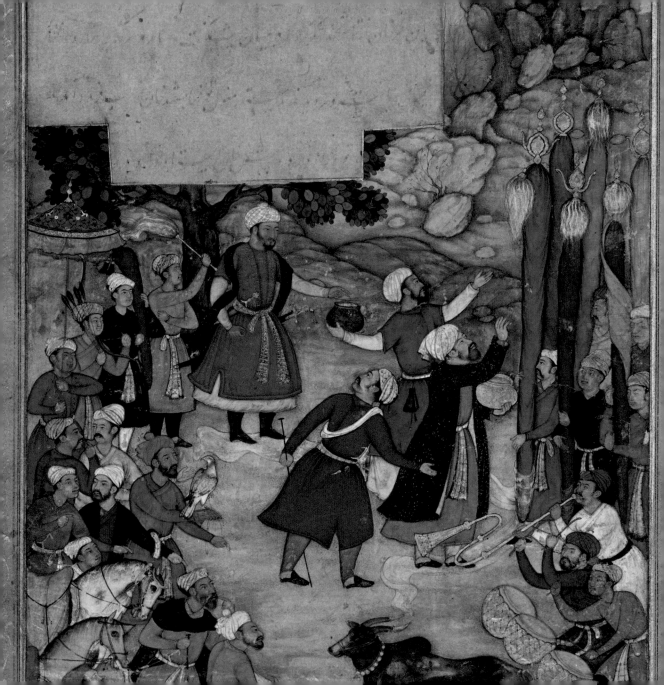

MOVING SOCIAL STATURE AND SPIRIT

ADRIANA PROSER
MR. AND MRS. THOMAS QUINCY SCOTT
CURATOR OF ASIAN ART

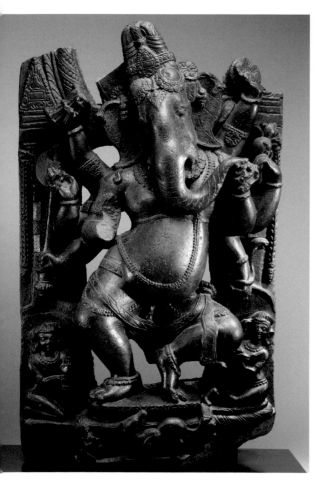

We humans often conceive of movement as more than simply a physical relocation; it can also describe a transformation in social stature or even a change from one metaphysical state to another. Many objects from the Walters Art Museum's Asian collections indicate the desire to transcend our present condition and move to higher social or spiritual realms. Perhaps no figure captures these wishes for progress better than Ganesha, a deity in the form of a chubby elephant-headed boy with a human body (Fig. 7). This beloved god who originated as one of the members of South Asia's Hindu pantheon is the son of the gods Shiva and Parvati. Among the many functions and qualities Ganesha is known for, one of the most popular is his purported ability to assist the faithful who appeal to him before setting out on any endeavor. His followers look to him for assistance in removing the

Fig. 7

Ganesha, India (Bihar or Bengal),
first half of 11th century, schist,
37¹³⁄₁₆ × 23¼ × 11⁹⁄₁₆ in. Gift of J. Gilman
d'Arcy Paul, 1967, acc. no. 25.49

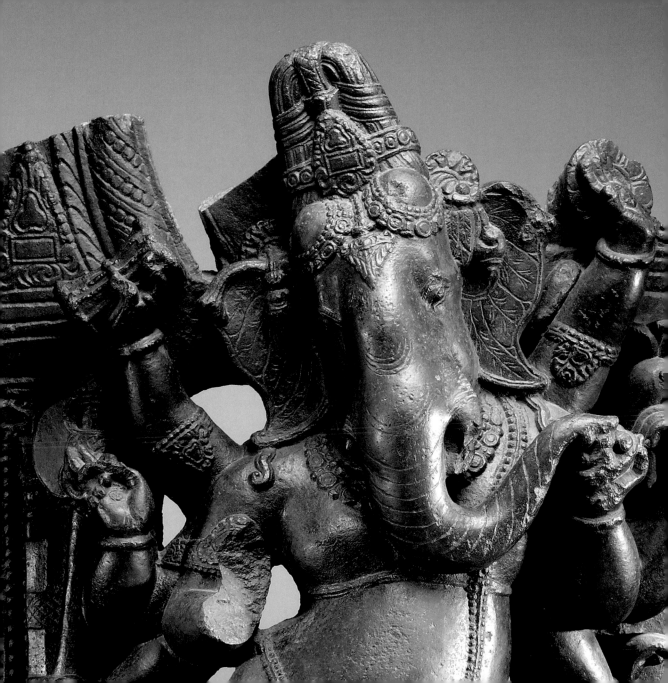

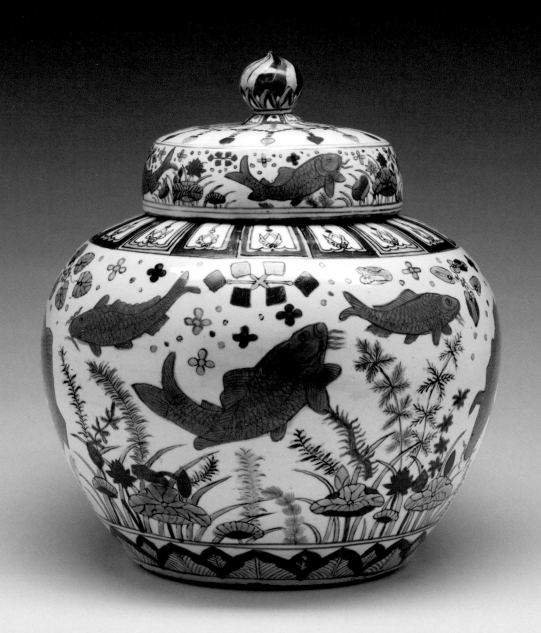

obstacles blocking their path toward advancement. The goal could be a worldly objective, like passing an exam, or a religious one, such as overcoming a sense of self that impedes one from the detachment required for a spiritual journey. Created for a stone temple niche in eastern India around the eleventh century, this large sculptural image of Ganesha—undoubtedly the recipient of many prayers for help removing roadblocks—captures the supple movement of the deity's bent knees in *Nritya-Ganapati* (his joyful dancing aspect). With his right foot planted, he raises his other foot so only the ball of the foot and toes touch the ground. Below him is his animal mount, a rat who can chew through any obstacles. Ganesha samples a sweet from one of eight hands, while in his others he holds seven other attributes, including an axe he uses to strike and repel impediments.

Fig. 8

Lidded Jar with Carp in Lotus Pond,
China, 1522–66, porcelain with underglaze
blue decoration and overglaze enamels,
17¹¹⁄₁₆, diam. 15¹³⁄₁₆ in. Acquired by Henry
Walters, before 1931, acc. no. 49.1917

Overcoming obstructions to upward social mobility is no easy feat, and in many places throughout Asia and the Islamic world, historically it has been virtually, if not completely, impossible for some segments of the population to advance in status. China is unique in that for over two thousand years, up into the early twentieth century, males born into any class had an opportunity for social mobility as a result of an examination system. Accordingly, any man who was able to score well enough on the government examinations could gain a position as a government official. This golden chance for an educated man to make an impressive jump from a lower class to what was culturally considered a position of respectability, often with comparative wealth, is symbolized in Chinese culture by the image of a carp swimming upstream. According to one popular legend, carp were capable of transforming into dragons with a single leap over the legendary Dragon Gate at the Yellow River's headwaters. As with the persistent fish, so too a man who dedicates himself to study and sitting for examinations can rise above. Through perseverance, the student has

the potential to demonstrate his abilities and successfully reach his goal of becoming an official. Further associations compound the image of a carp's implied wishes for success. What may at first glance appear to be simply a delightful aquatic scene on the surface of a Ming-dynasty (1368–1644) porcelain jar has deeper associations (Fig. 8). Created at the famed porcelain kilns at Jingdezhen in southeastern China in the early to mid-sixteenth century, a time when the number of scholars seeking government positions was rising to new heights, the jar's design features eight fish, called *bayu*, which when pronounced in Chinese sounds similar to the words for "vast fortune." Even the pronunciation of the word for carp itself, *liyu*, is a homonym for "profit." On this jar in overglaze *wucai*, or "five-color," enamel decoration, lively, auspicious carp swim across the surface among aquatic plants. Four more carp and aquatic plants evoking the fishes' natural habitat circle the perimeter of the jar's lid.

Imagery of creatures both real and fabulous emerged in China thousands of years before this everyday jar was decorated. Representations of such creatures also featured in funerary contexts. Their presence in tombs from around the first through the third centuries CE appears to relate to the belief that dragons linked the three realms of the heavens, earth, and underworld. Generally at this time, Chinese people believed that humans had two souls, and that one of the functions of dragons was to transport a deceased person's ethereal soul between this life and the afterlife. A painted ceramic sculpture of a dragon intended for a tomb is indicative of this understanding (Fig. 9). By the fourth century, around the time this beast was created, dragons were generally thought capable of numerous transformations. Though this dragon was made to be placed in a tomb where descendants hoped the corpse of the deceased and its earthly soul would remain, the

Fig. 9

Dragon, China, 4th–5th century, painted earthenware, 10⅛ × 2⅞ in. Gift of Mr. and Mrs. Edward L. Brewster, 1977, acc. no. 49.2425

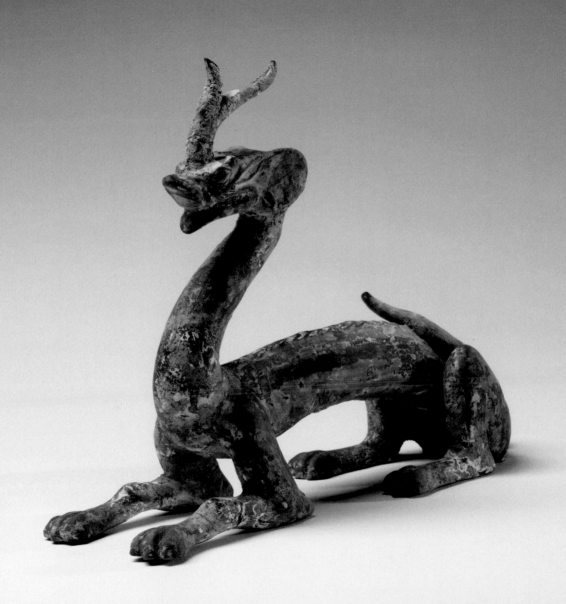

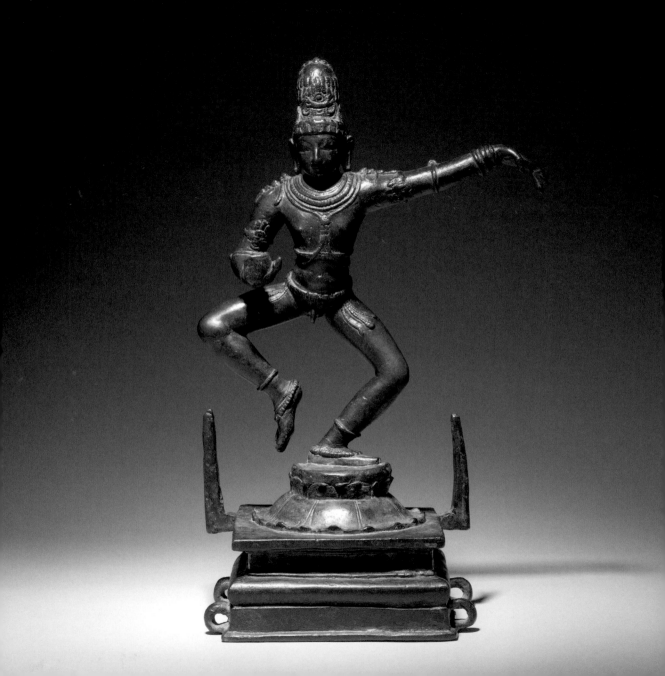

serpentine body and powerful feline legs of the creature clearly appear poised to spring and soar into the air, carrying the tomb occupant's ethereal soul to a Daoist paradise, perhaps the famed Kunlun Mountains, an abode of Daoist sages.

Asian art that implies spiritual movement also includes representations related to worldly ceremonial activity. Across cultures, processions provide an opportunity for both gathering socially and participating in a religious activity that is meant to convey both physical and spiritual action. The orchestrated movement of religious icons or paraphernalia through public streets provides the faithful with a unique chance to engage with these sacred objects. One such object is this tenth-century heavy, solid-cast but very graceful three-dimensional bronze sculpture of the Hindu god Krishna from South India's Tamil Nadu (Fig. 10). As is still true today, portable images depicting the presiding deity of a South Indian temple were paraded within and outside the temple compound along with an entourage of other deities. Access to the sacred spaces of a temple compound often depended on social status, but on festival days all could view the sculptures of the gods, who were elaborately dressed in silks and jewelry and decorated with colorful flower garlands. The two prongs visible on either side of this sculpture would have helped attach the garlands as they were draped near the figure. Icons were secured to poles or palanquins so they could be carried by more than one person or on a cart. Those transporting them carried them from within the temple compound and joined the faithful masses in the streets. There the deities received fruit and other offerings from those who venerated them. Accompanying priests chanted sacred texts and carried burning camphor as the faithful approached, hoping for spiritual and material blessings from the procession's presiding deity. The four lugs at the bottom of this sculpture would have been employed

Fig. 10

Krishna, India (Tamil Nadu), late 10th century, copper alloy, 14 3/8 × 8 11/16 × 5 9/16 in. Museum purchase with funds provided by the W. Alton Jones Foundation Acquisition Fund, 1993, acc. no. 54.2850

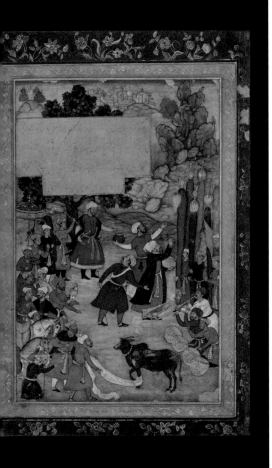

to help secure it to a wheeled wooden chariot-temple car pulled with ropes and bamboo poles in procession.

A scene from an album of Indian and Persian painting captures the ritual splendors of a procession in a different religious and cultural context. On this Islamic festival day, participants are gathered in a clearing and a city is visible in the distance (Fig. 11). To the right, musicians play drums and a horn just below a group of men holding up standards ('*alams*) that are colorfully festooned and towering above them. One elegantly dressed figure appears to be purifying these processional objects. 'Alams like these were traditionally fashioned from pierced iron (Fig. 12). This 'alam would have been similarly draped and featured in processions during

Fig. 11

A Festive Scene, from an album (*muraqqa'*), Iran and India, 16th–19th centuries, compiled in the 19th century, ink and paint on paper, 11⅝ × 7½ in. Acquired by Henry Walters, before 1931, acc. no. W.668, fol. 33a

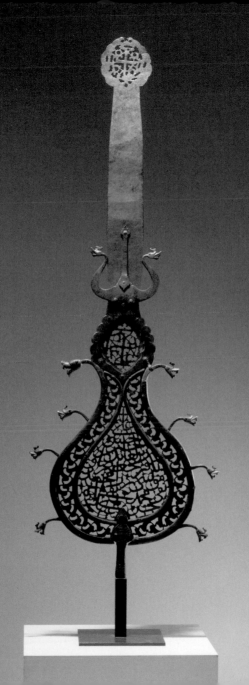

Fig. 12

Muhammad Taqi Urdubadi, *'Alam*,
Iran, 1664/65, iron, 49 7/16 × 16 5/8 × 3/8 in.
Museum purchase with funds provided
by the W. Alton Jones Foundation
Acquisition Fund, 2017, acc. no. 52.317

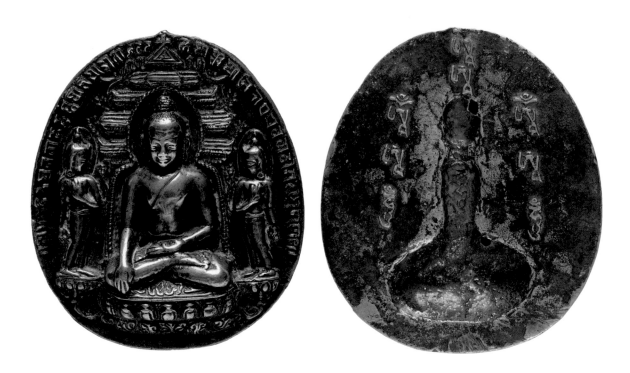

Fig. 13

Buddhist Votive Tablet, India, 11th century,
copper alloy, 3¾ × 3⁵⁄₁₆ × ¾ in. Gift of John
and Berthe Ford, 2008, acc. no. 54.3075

Muharram, the first month of the Islamic calendar, which commemorates the Battle of Karbala (680 CE), where Husain, the grandson of the Prophet Muhammad, was martyred. An inscription on the base of the 'alam states that it was made by Muhammad Taqi Urdubadi. The artist pierced the metal to form ornate calligraphic compositions of the names of twelve Shi'i successors to the Prophet Muhammad. Dragon heads with long necks protrude from the borders surrounding the calligraphy. Dragons were emblems of Muslim military regalia since at least the fourteenth century and were associated with religious legitimacy and sovereignty.

The presence of another faith, Buddhism, in China in the early centuries of the common era completely changed how many Chinese conceived of spiritual transformation. According to Buddhist teaching, which first emerged in South Asia, all sentient beings play an active role in how they spiritually develop. In order to progress toward an escape from the cycle of rebirth and suffering, they can, for example, devote themselves to positive actions and thoughts, and thereby gain merit that propels them toward their ultimate goal. One popular way of gaining merit is to go on pilgrimage. Numerous objects associated with Buddhist pilgrimage attest to the physical movement of pilgrims to sacred sites. This eleventh-century votive tablet is a small carving that a pilgrim would have attained in commemoration of a visit to Bodh Gaya in India, where the prince Siddhartha is believed to have attained enlightenment, thereafter becoming known as the Buddha Shakyamuni (Fig. 13). The object shows the Buddha at the moment of his enlightenment, meditating under the Bodhi tree and touching his right hand to the ground to summon the earth goddess to witness this great event. The plaque is inscribed with the Buddhist creed, which states that all things arise from a cause, but spiritual liberation can only be obtained by following the path of the Buddha. Tibetan letters on the back of the tablet suggest that it was made for a Tibetan who obtained it while on pilgrimage to India.

The practice of pilgrimage also features heavily in India's Hindu traditions. The faithful travel to sacred sites associated with deities that

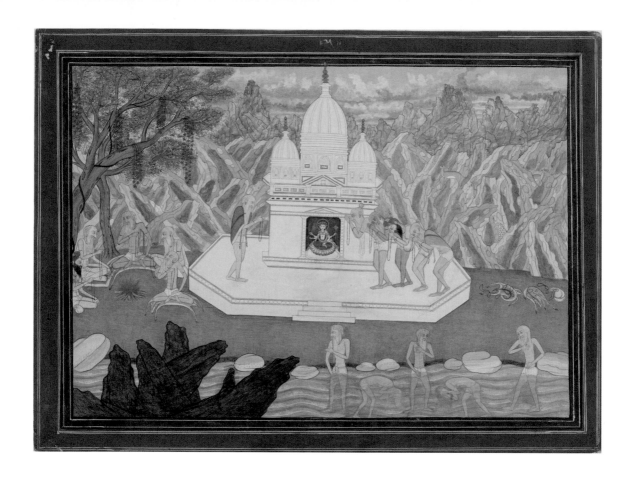

Fig. 14

**Ascetics before the Shrine of the
Goddess, from a dispersed series of the
Kedara Kalpa,** India, early 19th century,
pigments on paper, 14⅜ × 19⅜ in. Gift of
John and Berthe Ford, 2001, acc. no. W.859

are important to them and show their devotion to these gods in hope of receiving their blessings. A nineteenth-century Indian painting was formerly part of a series showing the long journey of five sages whose ultimate destination is Shiva's temple on Kendarnath in the Himalayas (Fig. 14). This leaf depicts the sages on their way as they stop at a shrine surrounded by high, icy mountains dedicated to the deity Gauri, who is also known as Parvati, consort of the god Shiva. The image of the goddess within the shrine can be seen at the center of the painting. The artist uses a common Indian visual device to show the actions of the sages at the shrine. Within the same composition they are depicted multiple times: purifying themselves in a river, venerating Gauri, and praying as they warm their emaciated bodies around a fire.

The paintings of pilgrimage to Kendarnath convey the levels of dedication required of the pilgrim. For Muslims the act is believed to be so spiritually transformative that pilgrimage, or *hajj*, is one of the five pillars of Islam. All Muslims who are physically and financially able are expected to make pilgrimage at least

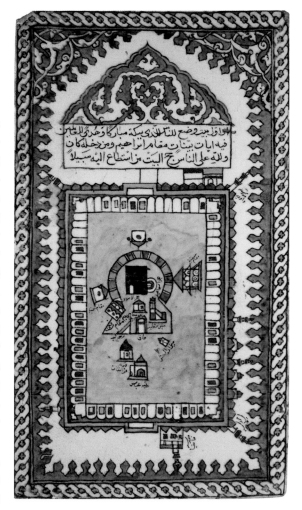

Fig. 15
Tile with the Great Mosque of Mecca,
Türkiye (İznik), 17th century, fritware ceramic with underglaze painting, 24 9/16 × 14 1/8 × 1 3/8 in. Acquired by Henry Walters, 1897, acc. no. 48.1307

once to the Great Mosque of Mecca, the location of the Ka'ba (from the Arabic word for "cube"), which within Islam is the omphalos—the navel or center of the world. A large tile made in the city of İznik, Türkiye, diagrams this most sacred destination in underglaze blue, turquoise, black, and red (Fig. 15). The dark square in the center indicates the Ka'ba, which pilgrims ritually walk around counterclockwise. Perhaps a teaching illustration for those about to embark upon the journey, a reminder to make pilgrimage to Mecca, or a commemorative plaque for a completed pilgrimage, the tile is a notable representation of a place that is a primary site for the physical and spiritual movement of the devoted.

Spiritual leaders set pathways for their followers. In the case of Muslims, chief among these is the Prophet Muhammad, who preached that there was only a single God. His journey to this realization is captured in the account of his Ascension. When Muhammad was sleeping one night, the Archangel Gabriel arrived to take him on a sojourn from Mecca in the Hejaz, the western edge of the Arabian Peninsula, to the Al-Aqsa Mosque in Jerusalem—the first leg of his *Isra'* (miraculous night journey). Upon reaching the mosque, he prayed with other prophets and Gabriel guided his *Mi'raj* (Ascension) to paradise, and subsequently hell. Ultimately, Muhammad came face to face with God. A manuscript painting illustrating the Ascension shows Muhammad with a white veil concealing his face (Fig. 16). He is flying upon his mount, the human-headed horse al-Buraq. The artist shows him against the night sky as al-Buraq gallops toward the Angel Gabriel. Golden lamps, a symbol of God's divine light, illuminate the sky.

Another great religious leader associated with a tale of ascension is Shakyamuni

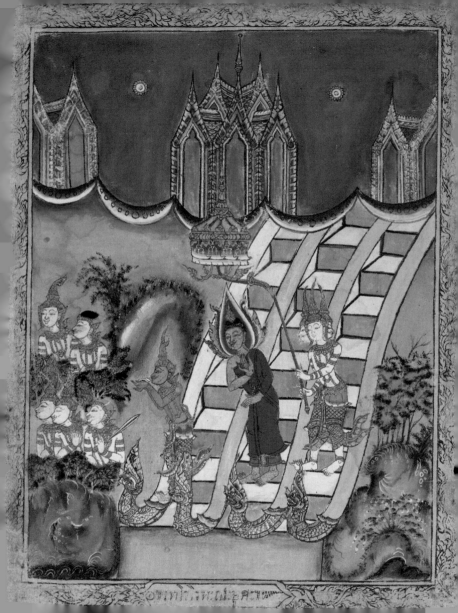

Buddha. Buddhist texts recount that because the Buddha's mother died seven days following his birth, she never had the opportunity to hear him preach. Seven years after his enlightenment, the Buddha ascended to his mother's abode, the Tavatimsa Heaven (one of several heavens in Buddhist cosmology), to share his teachings with her and her fellow inhabitants. But in illustrating the story of the Buddha's ascent, artists traditionally focus on an image of the Buddha after he has completed his objective. A Thai painting captures this conventional scene of the Buddha descending a celestial ladder back down to earth after he has preached to his mother in the Tavatimsa Heaven (Fig. 17). His companions in the composition are two figures that originated in the Hindu faith but also came to play roles in the Buddhist tradition. Indra is a protector of Buddhism and ruler of the Tavatimsa Heaven, shown with green skin and blowing a conch. Brahma is a protector of the Buddha's teachings, depicted in this painting with four heads and holding a parasol.

Whether objects of prayer, illustrations of inspirational events or places, or simply images that symbolize good wishes, a multiplicity of art made across Asia attests to the very human aspiration to improve the human condition by moving forward or upward mentally, socially, and spiritually.

Fig. 17

The Buddha's Descent from Tavatimsa Heaven, Thailand, 19th century, pigments on cloth, 25 × 18½ in. Gift from Doris Duke Charitable Foundation's Southeast Asian Art Collection, 2002, acc. no. 35.277

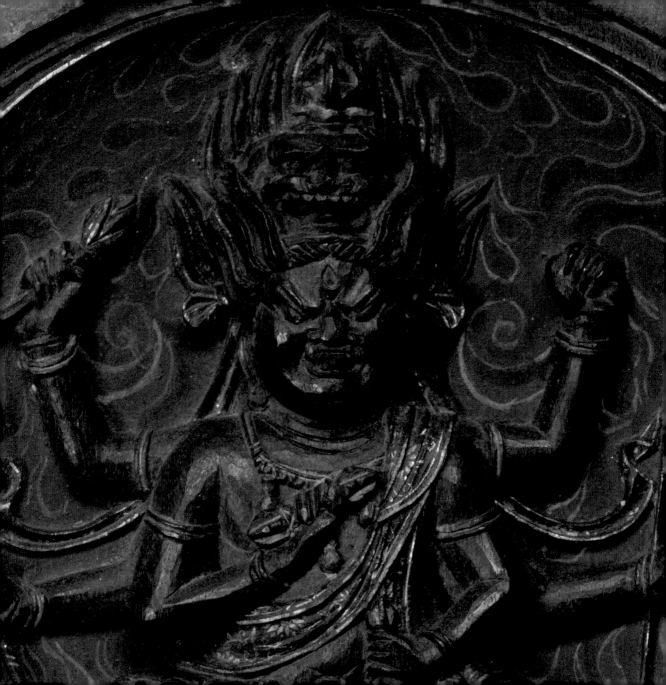

CARRYING CULTURE ACROSS LAND AND SEA

ASHLEY DIMMIG
WIELER-MELLON POSTDOCTORAL CURATORIAL
FELLOW IN ISLAMIC ART

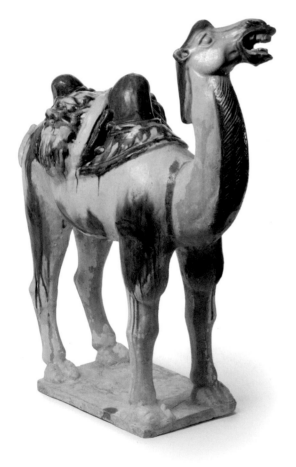

People have traversed the continent of Asia for millennia—whether motivated by basic survival, trade, religion, or political expansion. This movement has resulted in a constant flow and exchange of art, goods, religions, language, and culture more broadly, in times of both peace and war. The transportation of portable objects and the exchange of raw materials and finished goods, as well as ideas, resulted in the adoption and adaption of novel styles and techniques in local artistic practices across the Asian continent.

Perhaps there is no symbol more indicative of the transportation of trade goods overland across Asia than the camel. This animated Chinese ceramic sculpture of a Bactrian camel dates to the seventh or eighth century (Fig. 18), and its vibrant and colorful glazes are typical of those produced during the Tang dynasty (618–907). Though not native to China, this beast of

Fig. 18

Camel, China, 7th–8th century, earthenware with *sancai* glazes, 22⁷⁄₁₆ × 17⁷⁄₈ × 8 in. Museum purchase, 1949, acc. no. 49.2383

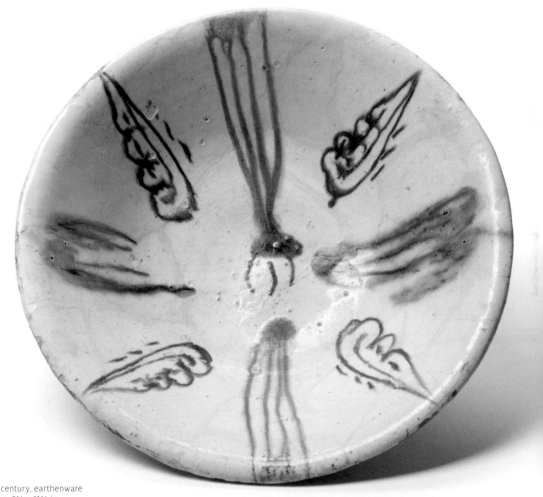

Fig. 19
Bowl, Iran, 10th century, earthenware ceramic with glaze, 3¼ × 11¼ in. Purchase from estate of D. G. Kelekian, acc. no. 48.2035

burden was a crucial means of transportation on the trade routes across the northwest deserts of Asia during the period in which this sculpture was made. Indeed, the camel came to symbolize commerce, exchange, and travel, especially between China and the many intercontinental kingdoms and cultures along the overland passages. These various routes are often called the Silk Road—though they certainly transported much more than just precious silk and constituted a vast network of roads. All kinds of raw materials and export goods were carried across the continent on the backs of camels and via caravans.

The ongoing trade across Asia facilitated artistic exchange as well, as embodied in this camel sculpture. The Chinese technique for glazing ceramic known as *sancai* (three glazes), most commonly executed in tones of green, off-white, and amber or ocher, inspired Persian ceramic artists, especially in the tenth century. In Persian artistic spheres, this glazing technique is known as *splashware*, given the fluid blending of color across the earthenware surface (Fig. 19).

Tradespeople, as well as pilgrims and migrants, brought their religious beliefs and practices with them as they traversed the continent. Over the centuries, different cultures adopted and adapted Hinduism, Buddhism, Islam, Christianity, and many other faiths—which is reflected in the art and devotional objects associated with each of these belief systems. A small Japanese locket made of lacquered wood features two Buddhist deities on the inside (Fig. 20). On the left is the bodhisattva Avalokiteshvara (Japanese: Kannon)—who embodies compassion for all living creatures—in the form of the 1,000-Armed Kannon. On the right is a ferocious-looking King of Desire named Aizen Myōō. The lion's head over his forehead indicates Aizen Myōō is capable of transforming lust into pure love. Known as a *kaichu zushi* or *mamori* (pocket amulet), this locket was originally made as a kind of micro-shrine to be carried in the pocket of a Buddhist priest's clothing for worship while traveling. Although made as a portable object for regular use, this locket survived the centuries because it was held as a sacred deposit inside a temple.

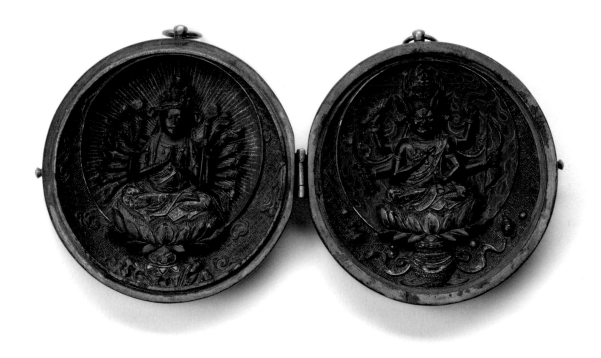

Fig. 20
Locket with Buddhist Deities, Japan,
13th century, sandalwood, lacquer, and
gilt bronze, 2½ × 4¾ × ½ in. Acquired by
William T. or Henry Walters, before 1931,
acc. no. 61.278

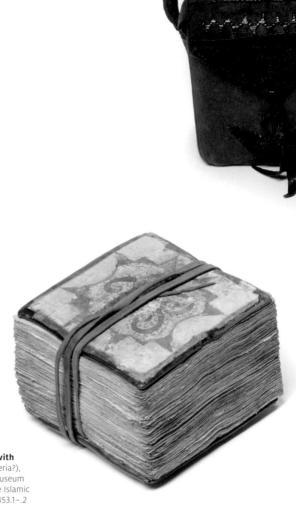

Devotional objects meant to be transported on the body and carried with the faithful as they traveled are common across many different religions. Copies of the Qur'an, the holy book of Islam, could be portable, as some were small enough to fit in one's palm or pocket. Such portable holy books also served to protect their bearers through the *baraka* (blessing) inherent in the word of God. One portable example is a square-format, loose-leaf copy of the Qur'an housed in two decorated leather pouches, each with bands that enable it to be worn or affixed to the body (Fig. 21). Made in sub-Saharan West Africa in the nineteenth century, the text is written in Sudani script in dark brown ink with vocalization indicators in red (Fig. 22). This folio contains the incipit (first words) of *Surat al-fatihah* (chapter 1), with the chapter heading inscribed in reddish-brown ink at the top of the page. As is typical of Qur'ans and visible on this opening page, it features

Fig. 21

Two-Volume Loose-Leaf Qur'an with Leather Pouches, West Africa (Nigeria?), 19th century, folio: 4 ⁵⁄₁₆ × 4 ⁵⁄₁₆ in. Museum purchase with funds provided by the Islamic Acquisition Fund, 2000, acc. no. W.853.1–.2

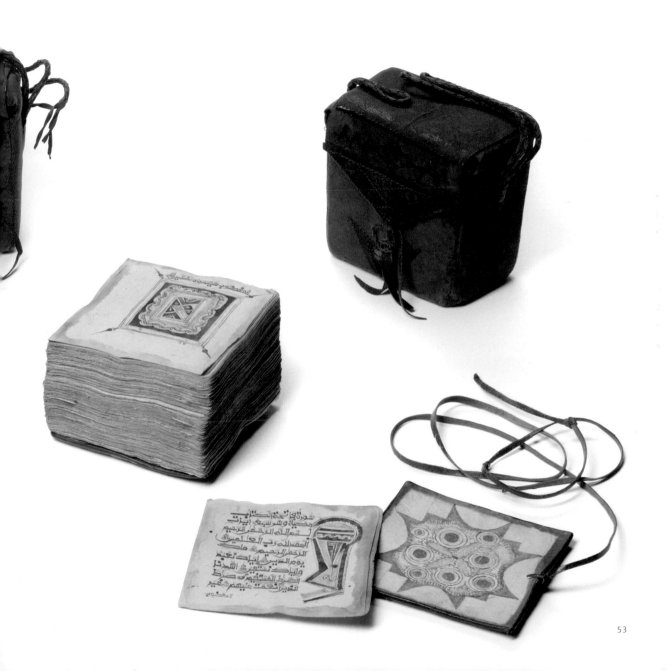

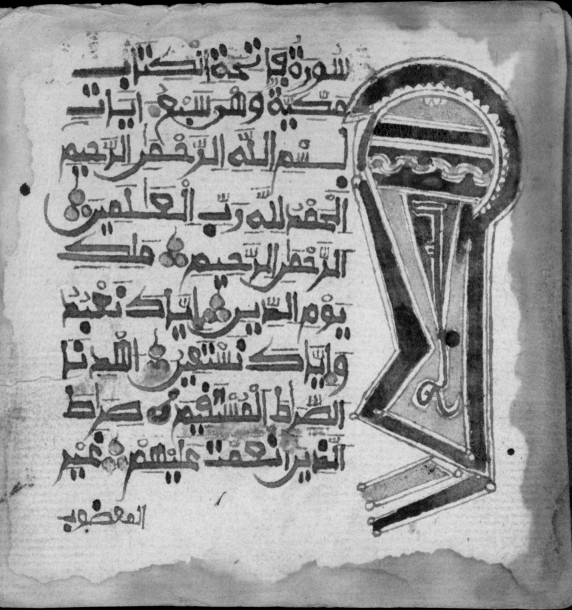

سورة فاتحة الكتاب

مكية وهي سبع آيات

بسم الله الرحمن الرحيم

الحمد لله رب العالمين

الرحمن الرحيم ٨ ملك

يوم الدين إياك نعبد

وإياك نستعين اهدنا

الصراط المستقيم ٩ صراط

الذين أنعمت عليهم غير

المغضوب

elements of illumination, not simply for adornment but as means to help the reader navigate the holy text. The three golden circles outlined in red throughout the text indicate breaks between verses, whereas chapter divisions appear as more intricate marginal ornamentation. In some cultures, the reading of a loose-leaf Qur'an such as this could be a communal activity; the pages would be dispersed among a group of reciters so that they all could be reading the holy text simultaneously. As a portable object, though, this Qur'an might have accompanied its owner on *hajj* (pilgrimage)—a journey all Muslims who are physically and financially able are obligated to undertake once in their lifetime—to visit Mecca, the holiest city in Islam, located in the Hejaz region of the Arabian Peninsula on the western edge of Asia. This journey could be a dangerous one, necessitating protection provided by the holy word of God in material form.

Fig. 22
Incipit from a Two-Volume Loose-Leaf Qur'an with Leather Pouches, West Africa (Nigeria?), 19th century, folio: 4⁵/₁₆ × 4⁵/₁₆ in. Museum purchase with funds provided by the Islamic Acquisition Fund, 2000, acc. no. W.853.1, fol. 2b

Another means by which Muslims can carry baraka with them while on the move is in the form of portable amulets or talismans. Such objects are made in various materials, from stone to paper. The entire surface of this printing matrix is engraved with Qur'anic verses, prayers, and invocations to God, the Prophet Muhammad, and other religious leaders (Fig. 23). It also contains representations of the Great Mosque of Mecca and the Mosque of Medina. Both the writing and images are engraved in reverse because the plaque was used for printing paper talismans. The resulting prints were dense but legible compositions, arranged in the form of a *hilye*, a kind of calligraphic image used for contemplation, originally developed by famed Ottoman calligrapher Hâfiz Osman (1642–1698). Anyone who acquired one of the prints could hang it in their home for divine protection, but they could also fold it up and keep it on their person, rendering the baraka stationary or portable, as needed.

The paper on which texts in the Islamic world commonly came to be written is an invention that emerged within the Asian continent

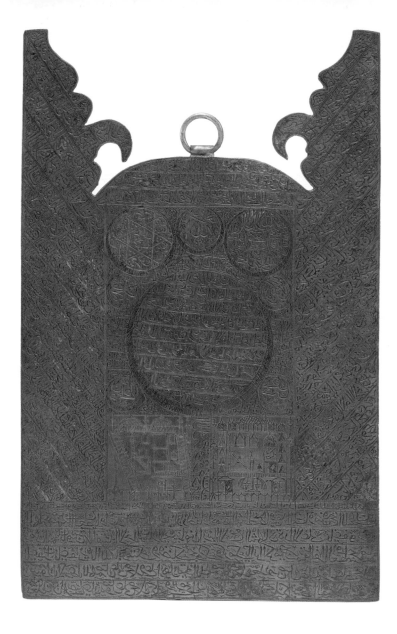

Fig. 23

Printing Matrix, Ottoman Empire,
19th century, engraved copper alloy,
10¹³⁄₁₆ × 6⅞ × ¼ in. Acquired by Henry
Walters, before 1931, acc. no. 54.510;
(right) detail of a digitally altered photograph
representing an imprint

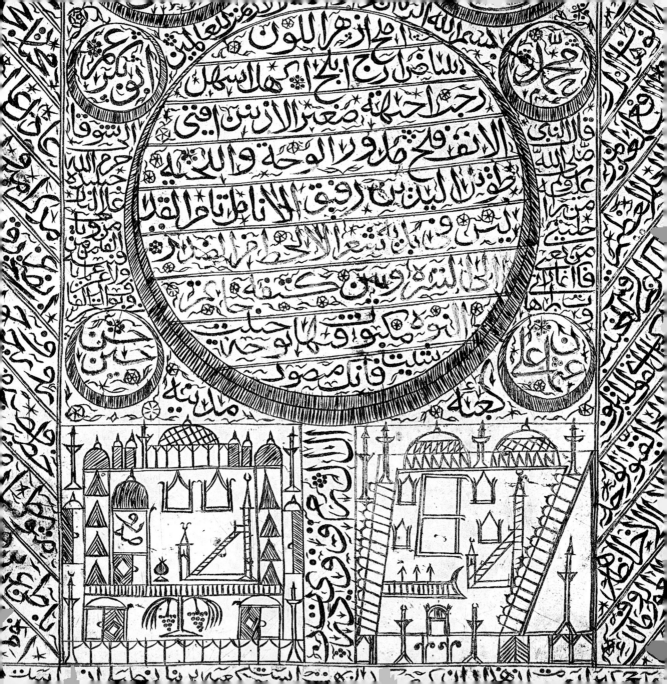

and spread westward from China. Islamic book production was irrevocably changed with the arrival of paper technology from East Asia, as it almost completely supplanted the use of parchment in manuscripts made in the Islamic world.

Paper-based art, both religious and secular, in various forms, naturally flourished in East Asia as well. A Chinese painting on paper once decorated a folding fan but was later mounted on a flat backing (Fig. 24). As an art form, folding fans became a necessary accessory to an elegant life in early modern China. Those among the educated and upper classes exchanged folding fans with pieces of paintings or calligraphy as gifts of friendship. As a portable art form, folding fans can be carried on the body and opened to reveal to viewers the rich culture and artistry they carry in their pleats. Indeed, possessing a folding fan with painting or calligraphy by a well-known artist was a status symbol and warranted public display. The painting on this paper fan depicts butterflies among lilies, an auspicious motif that speaks to maternal nourishment: just as the lily nourishes the butterfly, so do mothers nourish their children. Perhaps this fan was

given by the artist Yun Bing to a friend who was hoping for the birth of a male child, the favored gender for offspring in China at the time since sons were seen to carry on the ancestral line.

On the other side of the Asian continent, at the intersection with Europe and Africa, the Mediterranean Sea is vital to the exchange of goods, materials, technologies, and works of art beyond Asia. It was also the focus of Ottoman imperial growth and expansion during the fifteenth and sixteenth centuries. The Walters' collection of rare books and manuscripts is home to a copy of Piri Reis's *Book on Navigation*, which articulates the entire coastline of the Mediterranean Sea, as well as the Black and Caspian Seas (Fig. 25). The original text, composed by Piri Reis (1465–1553), an admiral in the Ottoman military, was a tour de force, compiling the detailed cartographical knowledge of the age. Piri Reis made two versions of his *Book on Navigation*, the first completed in 1521 and the second five years later. He states in the introduction that the purpose of the manuscript was to serve as an instructional tool for sailors, and it did become

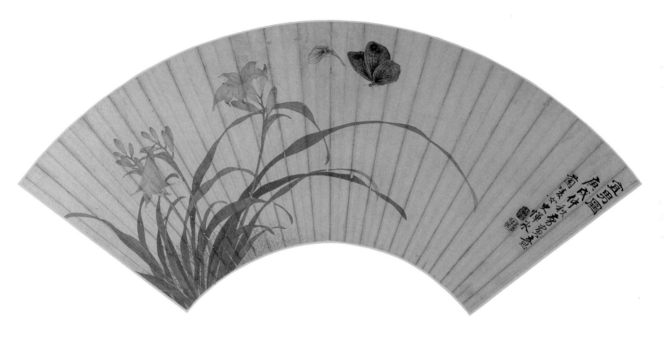

Fig. 24

Yun Bing, Fan Painting with Lilies and Butterflies, China, 1730, ink and color on cut-out and mounted paper, 6⁵⁄₁₆ × 17¹⁵⁄₁₆ in. Museum purchase with funds provided by the Ambassador and Mrs. William J. Sebald Fund, 1987, acc. no. 35.141

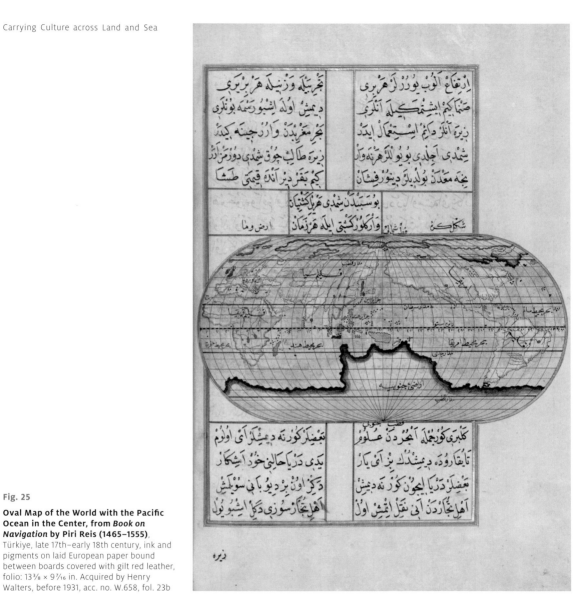

Fig. 25

Oval Map of the World with the Pacific Ocean in the Center, from *Book on Navigation* by Piri Reis (1465–1555), Türkiye, late 17th–early 18th century, ink and pigments on laid European paper bound between boards covered with gilt red leather, folio: 13⅜ × 9⁷⁄₁₆ in. Acquired by Henry Walters, before 1931, acc. no. W.658, fol. 23b

an important atlas and handbook of geography, but Piri Reis also created it as a gift for the Ottoman sultan, Süleyman the Magnificent (r. 1520–66), whom he served. A book on navigation was certainly an appropriate gift for a ruler who, among his many appellations, was known as the "Lord of the Lands and Seas," a title first claimed by Mehmed the Conqueror, who in 1453 vanquished the Byzantine empire and converted the city of Constantinople into his new imperial capital. Like his predecessor, Süleyman sought to expand his empire through conquest; he died at the Siege of Szigetvár in Hungary on his westward-moving campaign.

Though this version of the *Book on Navigation* preserves the original content compiled by Piri Reis, it was copied anew and illustrated by hand around the turn of the eighteenth century, more than a century after his death. This edition includes 249 maps and reflects the latest cartographical knowledge of the full globe, in particular the western edge of the Americas, which was still being actively colonized by European powers at this time. Indeed, mapping throughout history reflects the constantly changing borders of polities, which are often altered as a result of movement in the form of conquest or colonization. Maps are not neutral and can in fact change our perspective on the world. The opening sections of this densely illustrated copy of the *Book on Navigation* include a number of representations of the globe from various perspectives, such as this map of the world centered on the Pacific Ocean, which may seem quite different from the much more common Atlantic-centric one we are familiar with today.

These select artworks—whether personal possessions, devotional offerings, or objects that represent the vastness of the Asian continent, as in this depiction of the globe—demonstrate the dynamic movement and exchange of art across Asia and through time. The largest continent on Earth was and continues to be home to many diverse peoples who traverse land and sea, bringing trade goods, materials and technologies, religious beliefs, and artworks across borders, across cultures, and across the world.

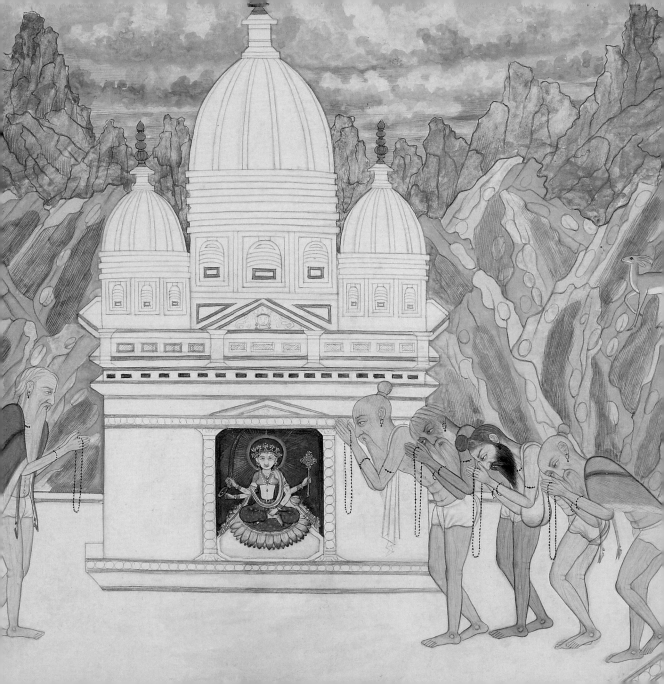

Selected Bibliography

Allan, James W. *The Art and Architecture of Twelver Shi'ism: Iraq, Iran and the Indian Sub-Continent*. London: Azimuth, 2011.

Barnes, Ruth, and Crispin Branfoot. *Pilgrimage: The Sacred Journey*. Oxford: Ashmolean Museum, 2006.

Carroll, Lynda. "Could've Been a Contender: The Making and Breaking of 'China' in the Ottoman Empire." *International Journal of Historical Archaeology* 3, no. 3 (September 1999): 177–90.

Chu, Petra ten-Doesschate, and Ning Ding, eds. *Qing Encounters: Artistic Exchanges between China and the West*. Los Angeles: Getty Research Institute, 2015.

Dehejia, Vidya. *The Thief Who Stole My Heart: The Material Life of Sacred Bronzes from Chola India, 855–1280*. Princeton, NJ: Princeton University Press, 2021.

Farhad, Massumeh, Simon Rettig, and François Déroche, eds. *The Art of the Qur'an: Treasures from the Museum of Turkish and Islamic Arts*. Washington, DC: Freer Gallery of Art and Arthur M. Sackler Gallery, Smithsonian Institution, 2016.

Ginsburg, Henry. *Thai Manuscript Painting*. Honolulu: University of Hawaii Press, 1989.

Gruber, Christiane. *The Praiseworthy One: The Prophet Muhammad in Islamic Texts and Images*. Bloomington: Indiana University Press, 2019.

Hepworth, Paul. "Production and Date of the Walters' 'Kitab-i Bahriye.'" *Journal of the Walters Art Museum* 63 (2005): 73–80.

Juliano, Annette L., and Judith A. Lerner. *Monks and Merchants: Silk Road Treasures from Northwest China; Gansu and Ningxia, 4th–7th Century*. New York: Abrams, 2001.

Landau, Amy, ed. *Pearls on a String: Arts, Patrons, and Poets at the Great Islamic Empires*. Seattle: University of Washington Press, 2015.

Pal, Pratapaditya. *Puja and Piety: Hindu, Jain, and Buddhist Art from the Indian Subcontinent*. Santa Barbara: Santa Barbara Museum of Art in association with University of California Press, 2016.

Porras, Stephanie. "Locating Hispano-Philippine Ivories." *Colonial Latin American Review* 29, no. 2 (2020): 256–91.

Rooney, Dawn F. *Bencharong: Chinese Porcelain for Siam*. Bangkok: River Books, 2018.

Simpson, Marianna Shreve. "Expanding Boundaries: A Manuscript of the Qur'an from Sub-Saharan Africa (W.853)." *Journal of the Walters Art Museum* 62 (2004): 237–39.

Simpson, Marianna Shreve. "'A Gallant Era': Henry Walters, Islamic Art, and the Kelekian Connection." *Ars Orientalis* 30 (2000): 91–112.

Ströber, Eva, ed. *Symbols on Chinese Porcelain: 10000 Times Happiness*. Stuttgart: Arnoldsche Art Publishers, 2011.

The Walters Art Museum: Excursions through the Collection. Baltimore: Walters Art Museum, 2020.

Weidner, Marsha, et al. *Views from Jade Terrace: Chinese Women Artists, 1300–1912*. Indianapolis: Indianapolis Museum of Art, 1988.

Wu, Yulian. "Chimes of Empire: The Construction of Jade Instruments and Territory in Eighteenth-Century China." *Late Imperial China* 40, no. 1 (June 2019): 43–85.

Index

Page numbers in *italics* refer to the illustrations.